Ohio

What's So Great About This State?

There is a lot to see and celebrate...just take a look!

CONTENTS
Land .pages 2–9
History. .pages 10–17
People .pages 18–25
And a Lot More Stuff!.pages 26–31

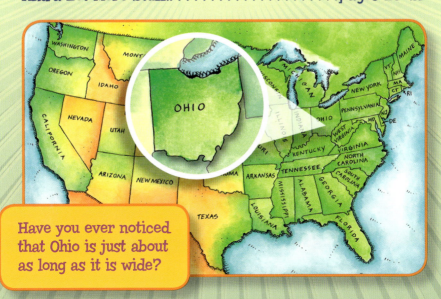

Have you ever noticed that Ohio is just about as long as it is wide?

What's So Great About This State?

Well, how about... the land!

From Lake Erie...

Glaciers last disappeared from Ohio about 10,000 years ago. But these huge masses of ice certainly left their mark on the state!

Lake Erie—which forms most of the northern border of the state—is a huge leftover "puddle" from the melting glaciers. But that's not all. Most of the land that the glaciers once covered is fairly flat (with just small rolling hills) due to the scraping action of the ice.

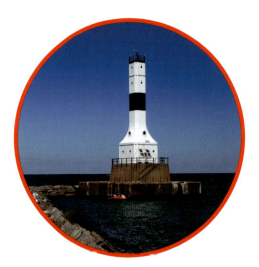

This Lake Erie lighthouse stands at the entrance to the Conneaut harbor. The city of Conneaut is in the most northeastern point of the Great Lakes Plains region.

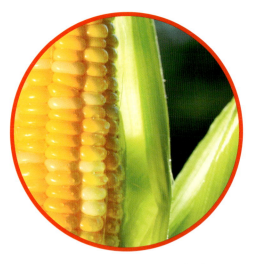

"Knee-high by the Fourth of July!" This old Midwestern saying refers to the height of corn—which is a crop that grows well in the rich soil of the Plains region.

...to the Ohio River

Southeastern Ohio has quite a different landscape. Not all of this area was affected by glaciers, so it has high hills, steep cliffs, and deep valleys.

The state is named after the Ohio River, which forms the southern boundary of the state. The river received its English name from an Iroquois word meaning "great river."

It's quite an adventure to explore the land across Ohio. Turn the page to see just some of the interesting places you can visit!

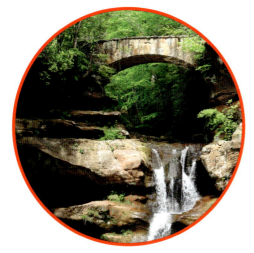

This waterfall is in Hocking Hills State Park in the Appalachian Plateau region of the state.

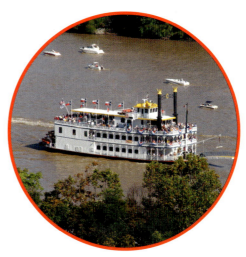

All sorts of boats—including a historic riverboat—travel the Ohio River.

Brandywine Creek runs through Cuyahoga National Park.

Plains

GREAT LAKES PLAINS

TILL PLAINS

There is plenty of farmland in the rolling hills of central Ohio.

About two-thirds of the state is part of the Plains region. The Great Lakes Plains surround the shores of Lake Erie. The Till Plains—named after the mixture of sand, gravel, rocks, and other "till" that the glaciers left behind—covers most of the western part of the state. The northern area is the flattest. The central and eastern parts of the Plains have more gently rolling hills.

What's so special about the Plains region?

Well, it's back to the glaciers again! Those huge masses of ice not only shaped the land, they also contributed to what's in it. Rich soil makes much of this region great for farming. In fact, Ohio is one of only four states in the country where over half of its land is suitable for growing crops. Corn and soybeans are two favorite crops.

What kind of things can I see in the Plains?

More than half of Ohio's state parks are in the Plains regions. That means lots of great picnic areas. There are also plenty of hiking and biking trails. Many different creatures live in this region including white-tail deer, raccoons, and red foxes, to name a few.

Don't forget the porcupines!

Yes, porcupines also live in the northern part of this area. However, you aren't too likely to run into these prickly creatures because they mostly come out at night.

By the way, porcupines can't really shoot their quills through the air. But if another animal comes in contact with them, the quills can detach with a painful stick.

The capital city of Columbus is in the Plains region.

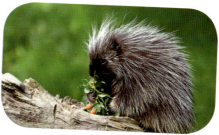

The porcupine has thousands of sharp-tipped quills that can make quite a point!

5

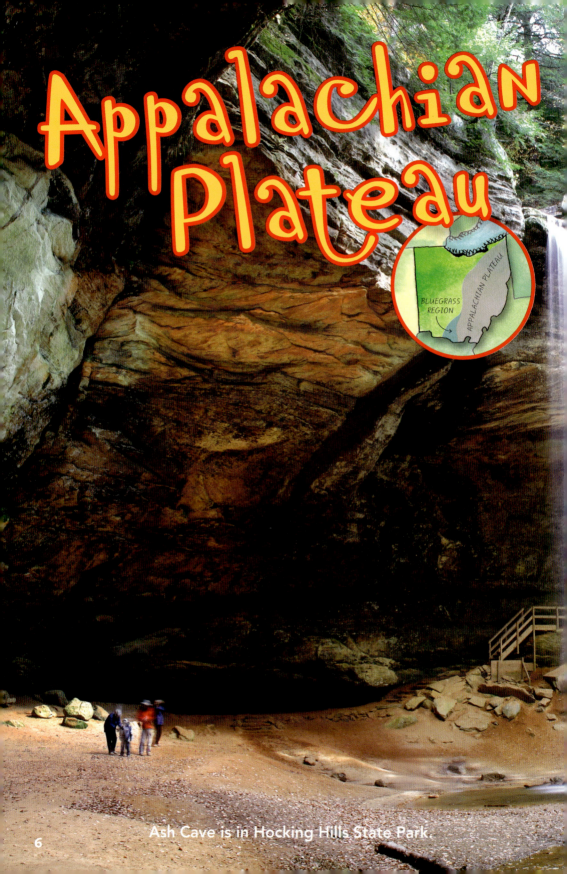

Appalachian Plateau

Ash Cave is in Hocking Hills State Park.

The Appalachian Plateau region that covers much of the eastern part of the state is part of the foothills of the Appalachian Mountains.

What's so special about the Appalachian Plateau region?

This region has Ohio's most abundant deposits of coal. But what's aboveground is far more beautiful! The northern part of the region consists of rolling hills and valleys. The southern part has steeper hills—waterfalls and valleys.

What can I see in the Appalachian Plateau region?

Lots of trees for sure! Some of the finest hardwood timber in the world is grown here—mostly oak and hickory. There are also some pretty amazing natural land formations. Rock Bridge in Hocking Hills State Park is the longest natural bridge in the state. This natural arch formed after thousands of years of erosion wore away the softer rock underneath the harder rock on top.

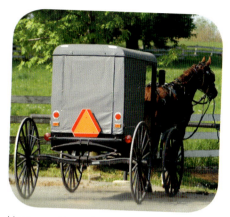

Horse and buggies are common in the Amish counties of the Appalachian Plateau region.

Don't forget the Bluegrass region!

A small region shaped like a triangle is at the very southern part of Ohio. It extends into Kentucky and Indiana and gets its name from a type of grass—bluegrass, of course—that is common in this area.

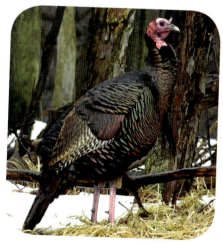

Once plentiful, wild turkeys disappeared from Ohio by 1904. However, natural populations gradually began moving back into southeastern Ohio. The bird is now slowly making a comeback throughout the state.

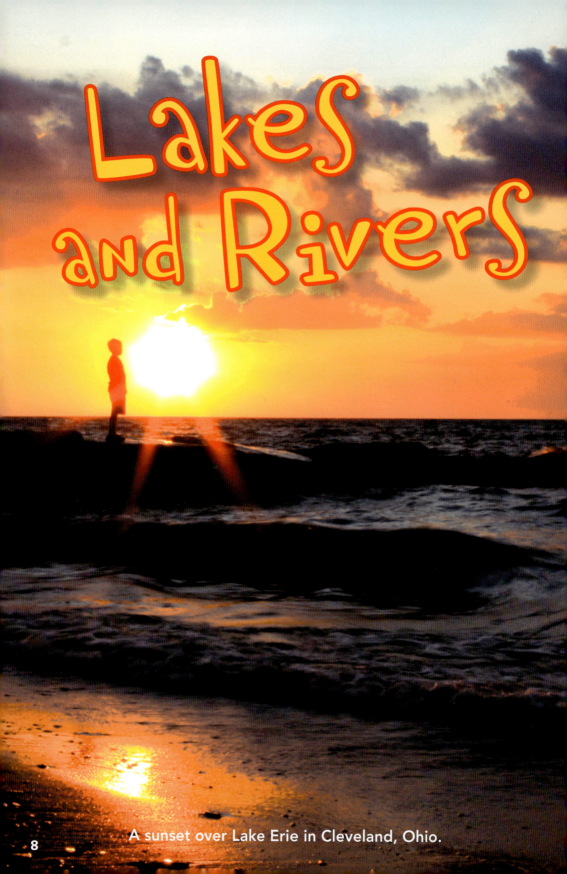

Lakes and Rivers

A sunset over Lake Erie in Cleveland, Ohio.

8

Natural and man-made lakes can be found throughout Ohio. The largest is the glacier-carved Lake Erie. There are also more than 3,300 named rivers and streams throughout the state.

Why are the lakes and rivers so special?

Lakes and rivers provide recreation, food, habitats, and water to drink! In Ohio, lakes and rivers have played an especially important role in transportation, too.

The Lake Erie shoreline makes Ohio part of the Great Lakes navigation system. This means ships from Ohio ports can connect with the Atlantic Ocean—and world markets—by way of the St. Lawrence Seaway.

At the southern end of the state, the Ohio River connects the state with a large inland river system. Huge barges move coal, petroleum products, and agricultural goods to and from over eighty five percent of the nation's major cities.

What can I see at lakes and rivers?

Punkys, goggle-eyes, and bullheads! A new rock group? Nope… these are the common names of some of the different kinds of fish swimming in Ohio's lakes and rivers.

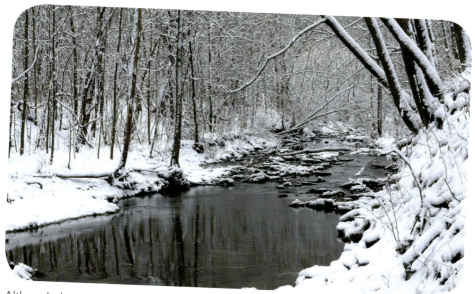

Although the water is still flowing in this creek in Keehner Park, cold Ohio winters can freeze the water in lakes, rivers, and creeks.

What's So Great About This State?

Well, how about... the history!

Tell Me a Story!

What is now Ohio was first settled by ancestors of Native Americans called the Paleoindians. Later prehistoric cultures, such as the Adena, Hopewell, and Fort Ancient, built raised burial mounds that are still around Ohio today.

By the mid 1600s, the Iroquois were trading furs with Dutch, British, and French traders. To expand their hunting territory, the powerful Iroquois Confederacy drove out other Native American tribes in the Ohio country. But during the 1700s, as the Iroquois tribes grew less powerful, other Native Americans including the Delaware, Miami, Ottawa, Mingo, and Wyandot moved back into the area.

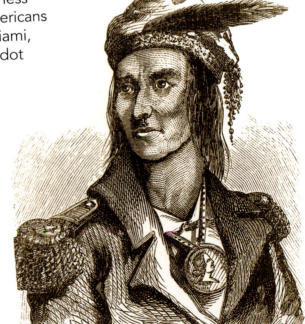

Tecumseh was a Shawnee leader who organized other tribes to resist white settlers. Tecumseh's Confederation eventually failed.

...The Story Continues

Eventually, Ohio became home to many other groups—including people of African, German, Irish, Scottish, English, Dutch, Swedish, and French ancestry. Many of the first settlers were farmers from the New England area. Later immigrants often came from Virginia, West Virginia, and Kentucky.

Although there were many French, Native American, and English battles over the years, the history of Ohio isn't all about war. Ohioans have always educated and invented. They have painted, written, sung, and built. Many footprints are stamped into the soul of Ohio's history. You can see evidence of this all over the state!

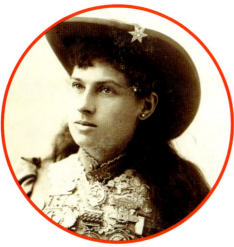

Annie Oakley (whose real name was Phoebe Ann Mozee) was born in Darke County, Ohio. She was an amazing sharpshooter who entertained people all over the world in Buffalo Bill's Wild West Show.

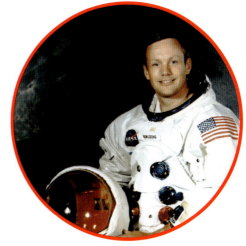

Neil Armstrong, from Wapakoneta, Ohio, was the first astronaut to walk on the moon. His historic message from the moon ("Tranquility Base here. The Eagle has landed.") was heard around the world on July 20, 1969.

The Hale Farm and Village is in Bath, Ohio.

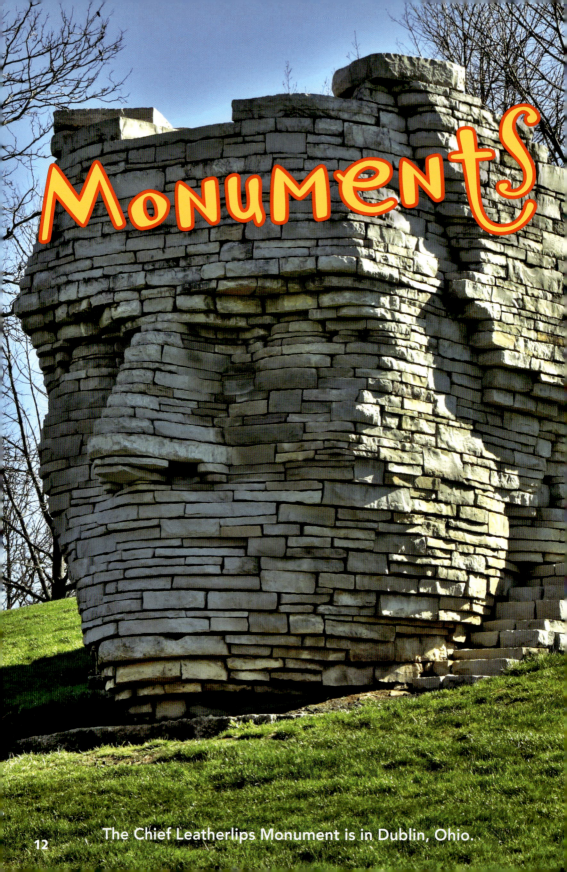

Monuments

The Chief Leatherlips Monument is in Dublin, Ohio.

Monuments and memorials honor special people or events. The Leatherlips Monument remembers Wyandot Chief Shateyaronyah. He was called "Leatherlips" by settlers because he had a reputation for keeping his promises—his word was as strong as leather.

Why are the monuments in Ohio so special?

That's an easy one! There were many special people who helped build the state of Ohio. Some were famous soldiers and politicians. Others were just ordinary people who did "extraordinary" things to help shape both the state of Ohio—and the nation.

What kind of monuments can I see in Ohio?

There are many different kinds. There are statues, monuments, plaques—almost every town has found some way to honor a historic person or event.

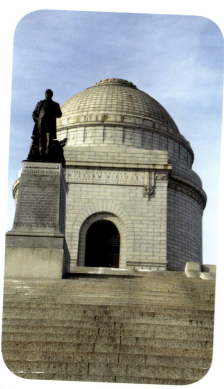

The McKinley National Memorial in Canton, Ohio honors William McKinley—the 25th president of the United States.

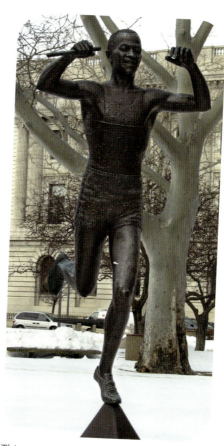

This statue in Cleveland honors athlete Jesse Owens, who won four gold medals in the 1936 Berlin Olympic Games.

Museums

The Rock and Roll Hall of Fame and Museum is in Cleveland, Ohio.

Museums don't just tell you about history—they actually show you artifacts from times past. Artifacts are things made by people, and they make history come alive!

Why are Ohio's museums so special?

Ohio's museums contain amazing exhibits with artifacts that tell the story of the state. For example, the National Underground Railroad Freedom Center Museum in Cincinnati tells the story of the Underground Railroad. During the 1800s, thousands of enslaved people sought freedom. The routes they traveled—and the people who helped them along the way—are considered part of the Underground Railroad.

What can I see in a museum?

An easier question to answer might be, "What can't I see in a museum?" There are thousands of items exhibited in all kinds of different museums across the state. Do you want to know about bicycles? The Pedaling History Bicycle Museum in New Bremen has the world's largest collection of antique and classic American bicycles. Are you interested in professional football? Then you might want to visit the Pro Football Hall of Fame in Canton, Ohio.

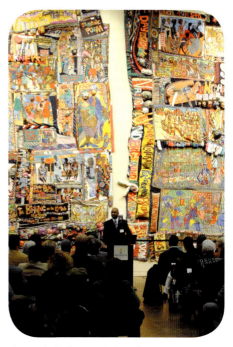

Aminah Robinson's RagGonNon art is at the National Underground Railroad Freedom Center. A RagGonNon is made of many things—including socks, beads, and music boxes—and it tells a rich story of African American life.

Imagine riding this high-wheel bike in 1885!

15

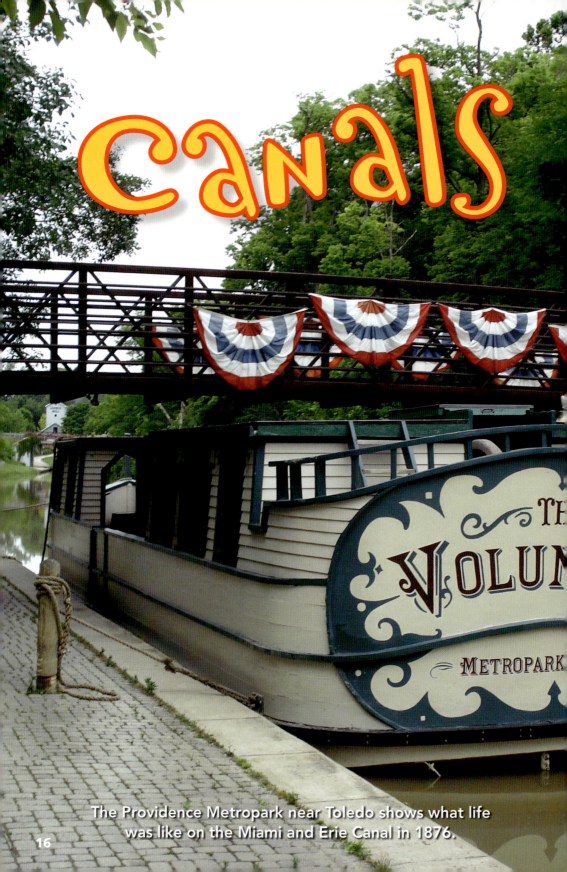

Canals

The Providence Metropark near Toledo shows what life was like on the Miami and Erie Canal in 1876.

The Towpath Trail in Cuyahoga Valley National Park follows the historic route of the Ohio and Erie Canal.

More than 250 miles of waterway made up the Miami and Erie Canal that once connected the Ohio River in Cincinnati with Lake Erie in Toledo. At one time, more than 1,000 miles of canal waterways ran throughout the state.

Why were canals built in Ohio?

Canals were a clever solution to a transportation problem! By the early 1800s, Ohio's population had grown to over a half million people. Most were farmers who needed a way to move their products to bigger markets in different parts of the state and to the East Coast. (Remember, railroads didn't yet exist in the state.) So canals—or man-made waterways—were a good solution. Canals were Ohio's first state-wide transportation system.

What kind of horsepower did the boats use?

The thousand-pound, hay-eating kind! Canal boats were pulled by horses, mules, or donkeys that walked on paths beside the canals. This means the boats could travel only as fast as the animals could walk—which was about four to five miles per hour. But the animals could pull lots more weight on water than they could on land, so more goods could be shipped at one time.

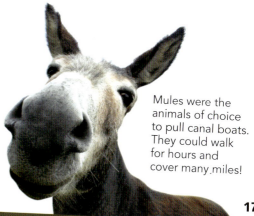

Mules were the animals of choice to pull canal boats. They could walk for hours and cover many miles!

What's So Great About This State?

Well, how about...
the people!

Enjoying the Outdoors

More than 11 million people live in the state of Ohio. Though they have different beliefs and traditions, Ohioans also have plenty in common.

Many share a love for the outdoors. Some of the best places for enjoying the great outdoors in Ohio are in the many state and national parks. And since Ohio has four seasons, choices for activities change all year long. Hiking in the fall, sledding in the winter, kayaking in the spring, swimming in the summer—the list of things that Ohioans enjoy goes on and on!

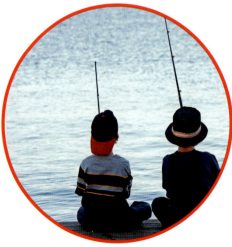

Fishing is popular in the summer.

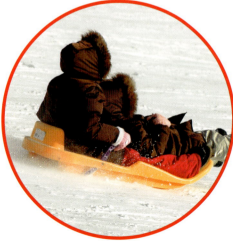

Sledding is great fun in the winter.

18

Sharing Traditions

In the towns and cities throughout the state, Ohioans share the freedom to celebrate different heritages. The great mix of cultures makes the state an interesting and exciting place to live.

For example, Central Ohio is home to the world's largest Amish community. The Amish trace their heritage back hundreds of years and still live and work much as their forefathers did.

Have you tried German sauerkraut or Italian sausage? How about buckeye candy? This popular Ohio treat looks like the nuts that fall from Ohio's state tree—the buckeye—but they're much tastier!

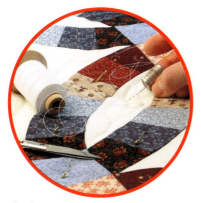

Making quilts is just one of the many crafts that are done by the Amish.

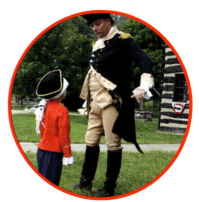

Ohio's history comes alive at Carillon Park in Dayton.

The trees throughout Ohio turn beautiful colors in the fall.

Protecting

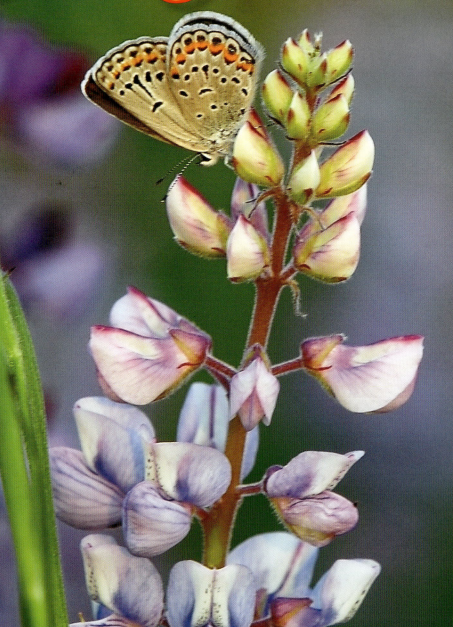

A female Karner Blue Butterfly feeds on a lupine plant.

20

When wild lupine plants disappeared from Ohio, the Karner Blue butterfly lost its food source—so it disappeared, too! Luckily, both the plant and the butterfly are making a comeback in the Kitty Todd Preserve in Lucas County.

Why is it important to protect Ohio's natural resources?

The state of Ohio covers more than 44,000 square miles so it has lots of different environments within its borders. From rolling plains to rushing waterfalls, different environments mean that different kinds of plants and animals can live throughout the state. In technical terms, Ohio has great biodiversity! This biodiversity is important to protect because it keeps the environments balanced and healthy.

What kinds of organizations protect these resources?

It takes a lot of groups to cover it all. The U.S. Fish and Wildlife Service is a national organization. The Ohio Department of Natural Resources and the Ohio State Parks Service are state organizations. Of course, there are many other groups such as the Audubon Society and the Rachel Carson Council.

And don't forget...

You can make a difference, too! It's called "environmental stewardship," and it means you are willing to take personal responsibility to help protect Ohio's natural resources.

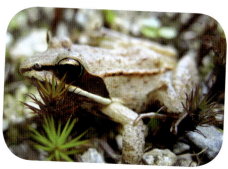

The Eastern Wood Frog becomes a "frogsicle" in the winter! Cold temperatures trigger a chemical reaction that allows the frog to produce special proteins and sugars to help it survive the winter. Although up to forty five percent of the frog's body can freeze, when warmer temperatures return in the spring, the frog thaws out just fine!

Inniswood Metro Gardens in Westerville is part of the central Ohio Metro Parks system that protects natural resources for people to enjoy.

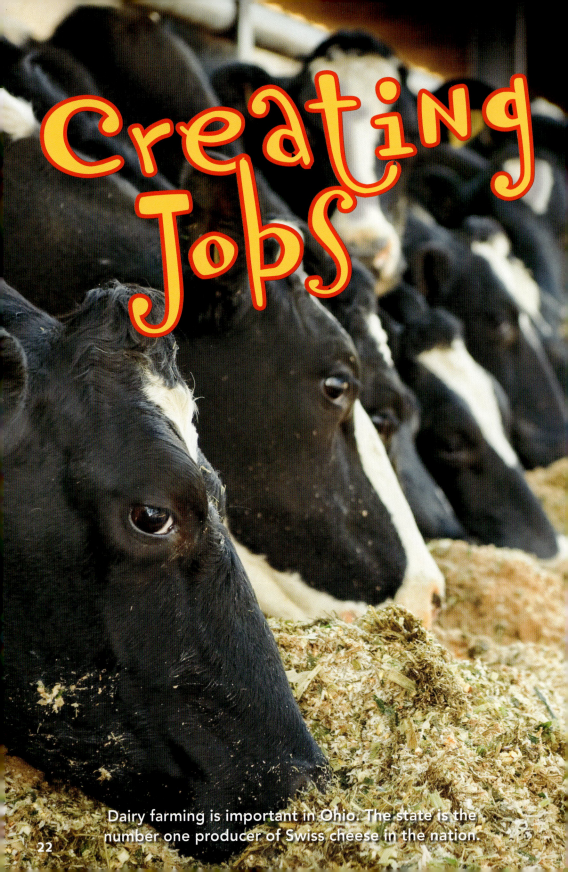

Creating Jobs

Dairy farming is important in Ohio. The state is the number one producer of Swiss cheese in the nation.

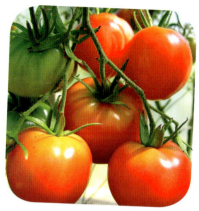

Tomatoes are an important crop. Tomato juice is even Ohio's state beverage.

Some jobs have been done in Ohio for a long time. Farming is one of them. Other jobs are newer to the state. These involve research and renewable energy industries.

Why is Ohio a good place for business?

The land and the people make a good combination for a variety of businesses throughout the state.

What kinds of jobs are available throughout the state?

Agriculture is big. Corn, soybeans, apples, and pumpkins are just some of the crops grown in Ohio. Trees are even grown as a crop, to produce timber, in places called "tree farms." The land also supports a variety of livestock. From cattle and chickens to sheep and alpacas, Ohio farms are very busy places.

Another big industry is the service industry. Chefs, waiters, hotel clerks—many jobs are needed to help tourists sightsee, eat, and relax!

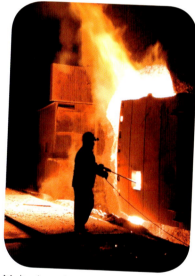

Melted steel is really hot! Ohio is one of the largest steel-producing states in the country.

Don't forget the military!

The Air Force, Army, Marines, Navy, and Coast Guard can all be found in the state. Ohioans have a great respect for all the brave men and women who train and work to serve our country.

Military training is hard work!

Celebrating

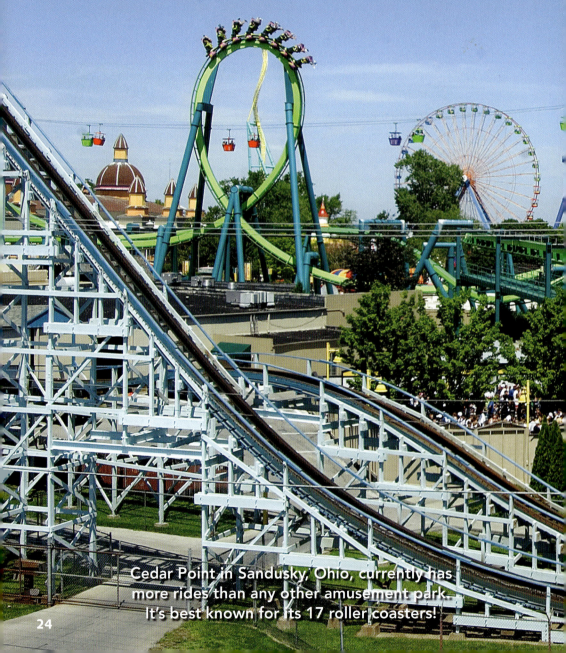

Cedar Point in Sandusky, Ohio, currently has more rides than any other amusement park. It's best known for its 17 roller coasters!

The people of Ohio really know how to have fun! Cedar Point draws seven million visitors each year. It's one of the most popular places for people to visit in the whole state!

Why are Ohio festivals and celebrations special?

Celebrations and festivals bring people together. From cooking to frog-jumping contests, events in every corner of the state showcase all different kinds of people and talent.

What kind of celebrations and festivals are held in Ohio?

Too many to count! But one thing is for sure. You can find a celebration for just about anything you want to do. Do you like to eat corn on the cob? Ohio has seven different corn festivals every year. The Millersport Corn Festival at Buckeye Lake has been a celebration for over 60 years.

Do you like to watch car races? The Mid-Ohio Sports Car Course in Lexington races all kinds of cars, with some reaching 180 miles per hour. Want to see hot-air balloons? There are nine different hot-air balloon festivals each year throughout the state.

Don't forget the bathtub races!

Yes, it's true. Racing in bathtubs is all part of the Maple Festival in Chardon, Ohio. At this festival people celebrate the making (and eating!) of tasty maple syrup.

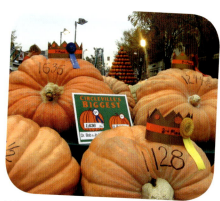

Winners of the 2009 Biggest Pumpkin contest at the Circleville Pumpkin Festival. The number on each pumpkin tells how many pounds it weighs!

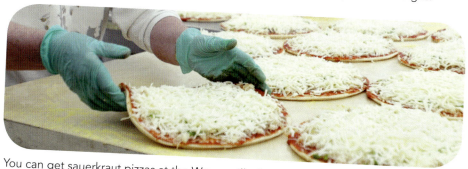

You can get sauerkraut pizzas at the Waynesville Sauerkraut Festival. You can even get sauerkraut fudge!

Birds and Words

What do all the people of Ohio have in common? These symbols represent the state's shared history and natural resources.

State Bird
Cardinal

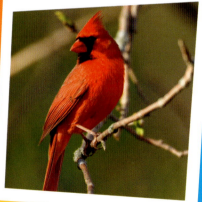

State Tree
Ohio Buckeye

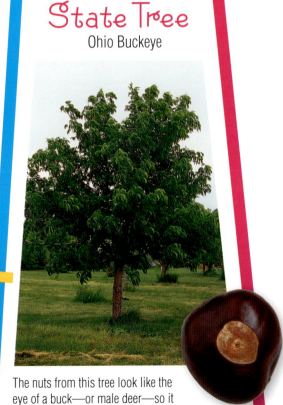

The nuts from this tree look like the eye of a buck—or male deer—so it is named the buckeye.

State Flower
Scarlet Carnation

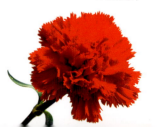

State Native Fruit
Pawpaw

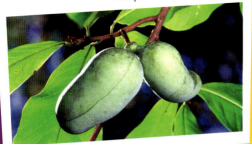

State Flag
Adopted 1902

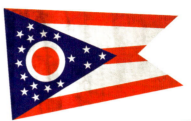

State Reptile
Black Racer

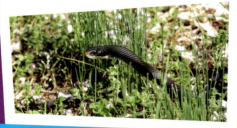

State Mammal
White-tailed Deer

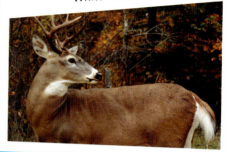

State Insect
Ladybug

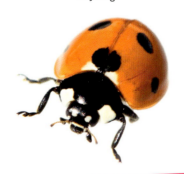

State Wildflower
White Trillium

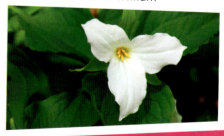

Want More?

Statehood—March 1, 1803
State Capital—Columbus
State Nickname—Buckeye State
State Song—"Beautiful Ohio"
State Rock Song—"Hang on Sloopy"
State Beverage—Tomato Juice
State Fossil—Trilobite (*Isotelus*)
State Gemstone—Flint

More Fun Facts

More
Here's some more interesting stuff about Ohio.

First City
Marietta (originally known as Adelphia) was the first settlement in the Northwest Territory in 1788.

President Patch
Seven U.S. presidents were born in Ohio: Ulysses S. Grant, Rutherford B. Hayes, James A. Garfield, Benjamin Harrison, William McKinley, William H. Taft, and Warren G. Harding.

Everyone Welcome
Oberlin College (founded in 1833) was the first interracial and coeducational college in the United States.

Toad Tuning
At the Cedar Bog in **Urbana**, people gather each spring to hear the toads sing! The bog's toads (and frogs!) are famous for their loud singing to attract a mate.

Weather Wonder
Buckeye Chuck is a groundhog from **Marion** known for predicting the arrival of spring.

Lights, Camera, Action
Some movies made in Ohio include *The Shawshank Redemption*, *Air Force One*, *A Christmas Story*, and *Rain Man*.

Big Business in Buttons
In the early 1900s the biggest employer in **Manchester** was the Manchester Button Factory. Mussel shells from the nearby Ohio River supplied the raw material.

Zip It!
The B.F. Goodrich company in **Akron** used inventor Gideon Sundback's fastener on a new type of rubber boot—and the name "zipper" was born.

Super Serpent
The prehistoric Fort Ancient culture built a 1,348-foot-long mound in the shape of a serpent that you can still see today in Adams County, Ohio.

Sewing Freedom
In the mid-1800s, women organized an Anti-Slavery Sewing Society in **Cincinnati** to make new clothing for people who were escaping slavery through the Underground Railroad.

An Apple a Day
Many of Ohio's first apple orchards began with saplings from John Chapman, better known as Johhny Appleseed.

Town Tribute
Mount Vernon, Ohio is named after the home of George Washington, which is Mount Vernon, Virginia.

Bienvenidos
Ohio's Hispanic community has grown by more than 22 percent since the year 2000.

Glass City Goes Solar
The first mass-produced glass bottles came from **Toledo**. Now the city is becoming known for producing glass solar panels.

Ohio River(s)
Major rivers in Ohio include the **Ohio**, **Cuyahoga**, **Great Miami**, **Maumee**, **Muskingham**, and **Scioto** rivers.

Pennant-Shaped Flag
The state flag of Ohio is the only state flag that is not shaped like a rectangle. The flag has a burgee design, which means it is cut in on one end—more like a pennant.

World's Largest Basket
The Longaberger Basket headquarters in **Newark** is a seven-story office building—shaped like a basket!

Wade In
Lake Erie is the shallowest of the Great Lakes.

29

Find Out More

There are many great websites that can give you and your parents more information about all the great things that are going on in the state of Ohio!

State Websites

The Official Website of the State of Ohio
www.ohio.gov

Ohio State Parks
www.ohiodnr.com/parks

The Official Tourism Site of Ohio
www.discoverohio.com

Museums

Columbus

The Ohio Historical Society
www.ohiohistory.org

The Center of Science and Industry
www.cosi.org

Cleveland

The Children's Museum of Cleveland
www.clevelandchildrensmuseum.org

The Cleveland Museum of Natural History
www.cmnh.org

The Rock and Roll Hall of Fame and Museum
www.rockhall.com

Cincinnati

The National Underground Railroad Freedom Center
www.freedomcenter.org

The Cincinnati Museum Center at Union Terminal
www.cincymuseum.org

Toledo

The Toledo Firefighters Museum
www.toledofiremuseum.com

Akron

The National Inventors Hall of Fame
www.invent.org

Dayton

The National Museum of the US Air Force
www.nationalmuseum.af.mil

Aquariums and Zoos

The Cleveland Aquarium
www.clevelandaquarium.org

The Columbus Zoo and Aquarium
www.columbuszoo.org

The Toledo Zoo
www.toledozoo.org

The Cincinnati Zoo
www.cincinnatizoo.org

Ohio: At A Glance

State Capital: Columbus

Ohio Borders: Pennsylvania, West Virginia, Kentucky, Indiana, Michigan, Lake Erie

Population: About 11 million

Highest Point: Campbell Hill is 1,549 feet (472 meters) above sea level

Lowest Point: Extreme southwestern Ohio at about 455 feet (139 meters) above sea level

Some Major Cities: Columbus, Cleveland, Cincinnati, Toledo, Akron, Dayton

Some Famous Ohioans

Dorothy Dandridge (1922–1965) from Cleveland, OH; was an actress and first African American to be nominated for an Academy Award.

Paul Laurence Dunbar (1872–1906) from Dayton, OH; was a nationally recognized American poet.

Thomas A. Edison (1847–1931) from Milan, OH; was an inventor who created such things as the lightbulb.

Benjamin F. Goodrich (1841–1888) lived in Akron, OH; was a surgeon and businessman who founded the B. F. Goodrich company.

Macy Gray (born 1967) from Canton, OH; is a Grammy Award-winning singer, songwriter, and record producer.

Charles Kettering (1876–1958) from Loudonville, OH; was an inventor who created such things as the first electric ignition system for cars.

Judith Resnick (1949–1986) from Akron, OH; was an astronaut for NASA who received the Congressional Space Medal of Honor.

Harriett Beecher Stowe (1811–1896) lived in Cincinnati, OH; was a novelist who wrote the anti-slavery story *Uncle Tom's Cabin*.

Orville Wright (1871–1948) from Dayton, OH; was an inventor who, with his brother Wilbur, built and successfully flew the first airplane.

Granville T. Woods (1856–1910) from Columbus, OH; was an inventor of such things as a telegraph that allowed messages to be sent from moving trains.

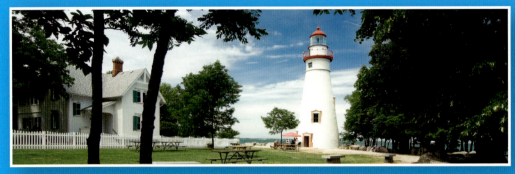

Marblehead lighthouse on Lake Erie

CREDITS

Series Concept and Development
Kate Boehm Jerome

Design
Steve Curtis Design, Inc. (www.SCDchicago.com); Roger Radtke, Todd Nossek

Reviewers and Contributors
Dr. Connie Bodner, Director, Education and Interpretation Services, Ohio Historical Society;
Terry B. Flohr, writer and editor; Mary L. Heaton, copy editor; Eric Nyquist and Todd Nossek, researchers

Photography
Back Cover(a) © photosbyjohn/Shutterstock; Back Cover(b), 7a © Rena Schild/Shutterstock; Back Cover(c), 24-25 Courtesy Cedar Point Amusement Park/Resort, Sandusky, OH; Back Cover(d), 8-9, 14-15 © Robert J. Daveant/Shutterstock; Back Cover(e), 6-7, 9, 17a © Doug Lemke/Shutterstock; Cover(a) © Bryan Busovicki/Shutterstock; Cover(b), 27d © Mike Rogal/Shutterstock; Cover(c), 26a © RLHambley/Shutterstock; Cover(d), 2b © Sandra Cunningham/Shutterstock; Cover(e) Courtesy of the Ohio Statehouse Photo Archive; Cover(f) © Phil Berry/Shutterstock; 2-3 © Jeff Hackett/Shutterstock; 2a © Dave Kerr/Shutterstock; 3a © Jennifer Stone/Shutterstock; 3b © vadim kozlovsky/Shutterstock; 4-5 © Weldon Schloneger/Shutterstock; 5a © Cynthia Kidwell/Shutterstock; 5b © Tony Rix/Shutterstock; 7b © Bruce MacQueen/Shutterstock; 10-11 © Caitlin Mirra/Shutterstock; 10a © Indiana Historical Society; 11a © Billy Rose Theatre Collection/NYPL; 11b Courtesy NASA; 12-13 By Karl Hassel; 13a © Jesse Kunerth/Shutterstock; 13b By Donna Woods; 15a Courtesy National Underground Railroad Freedom Center; 15b © Ahmed Abusamra/Shutterstock; 16-17 By Dave Barber; 17b © electerra/Shutterstock; 18-19, 21b, 26d © aceshot1/Shutterstock; 18a © sonya etchison/Shutterstock; 18b © aquatic creature/Shutterstock; 19a © Christina Richards/Shutterstock; 19b Courtesy Dayton History/Carillon Park; 20-21 © Jon Cross/ohio-nature.com; 21a © MichaelZahniser/Wikimedia; 22-23 © Jean Frooms/Shutterstock; 23a © Olga Lipatova/Shutterstock; 23b © Studio 37/Shutterstock; 23c © John Wollwerth/Shutterstock; 25a Nyttend/Wikimedia; 25b © The Dayton Daily News; 26b Courtesy USDA-NRCS PLANTS Database/Herman, D.E.; 26c © Mihai Simonia/Shutterstock; 27a Scott Bauer, USDA; 27b © Hintau Aliaksei/Shutterstock; 27c © Darryl Vest/Shutterstock; 27e © Eric Isselée/Shutterstock; 27f © Olga Utlyakova/Shutterstock; 28 © Terence Mendoza/Shutterstock; 29a © Olegro/Shutterstock; 29b By Derek Jensen (Tysto)/Wikimedia; 31 © R. Gino Santa Maria/Shutterstock; 32 © Michael Shake/Shutterstock

Illustration
Back Cover, 1, 4, 6 © Jennifer Thermes/Photodisc/Getty Images

Copyright © 2010 Kate Boehm Jerome. All rights reserved. No part of this book may be used or reproduced in any manner without written permission except in the case of brief quotations embodied in critical articles and reviews.

ISBN 978-1-58973-015-1
Library of Congress Catalog Card Number: 2009943371

1 2 3 4 5 6 WPC 15 14 13 12 11 10

Published by Arcadia Publishing
Charleston SC, Chicago IL, Portsmouth NH, San Francisco CA

For all general information contact Arcadia Publishing at:
Telephone 843-853-2070
Fax 843-853-0044
Email sales@arcadiapublishing.com
For Customer Service and Orders:
Toll Free 1-888-313-2665

Visit us on the Internet at www.arcadiapublishing.com